*The Heart ~
Many Doors*

American Poets Respond
to Metka Krašovec's Images
Responding to Emily Dickinson

Edited by Richard Jackson

WingsPress

San Antonio, Texas
2017

Cover image: "Triple Mirror" © 1992 by Metka Krašovec. Painting, 145 x 160 cm. Interior drawings, 2010-12, by Metka Krašovec. Drawings 12.5 x 18 cm. All art used by permission of the artist.

ISBN: 978-1-60940-536-6 (paperback original)
E-books:
epub: 978-1-60940-537-3
Mobipocket/Kindle: 978-1-60940-538-0
Library PDF: 978-1-60940-539-7

Wings Press
627 E. Guenther
San Antonio, Texas 78210
Phone/fax: (210) 271-7805
On-line catalogue and ordering:
www.wingspress.com
Wings Press books are distributed to the trade by
Independent Publishers Group
www.ipgbook.com

Library of Congress Cataloging-in-Publication Data

Names: Jackson, Richard, 1946- editor. | Kraésovec, Metka, 1941- illustrator.
 Dickinson, Emily, 1830-1886.
Title: The heart's many doors : American poets respond to Metka Kraésovec's images responding to Emily Dickinson / edited by Richard Jackson.
Description: San Antonio, Texas : Wings Press, 2017.
Identifiers: LCCN 2016043986 | ISBN 9781609405366 (paperback) | ISBN 9781609405380 (kindle/mobipocket ebook) | ISBN 9781609405397 (library pdf) | ISBN 9781609405373 (ePub)
Subjects: LCSH: American poetry--21st century. | Art--Poetry. | Influence (Literary, artistic, etc.) | Kraésovec, Metka, 1941--Poetry. | Dickinson, Emily, 1830-1886--Poetry. | BISAC: POETRY / American / General. | ART / European.
LCC PS595.A75 H44 2017
DDC 811/.6080357--dc23
LC record available at https://lccn.loc.gov/2016043986

The Heart's Many Doors

Poetry inspires art,
art inspires poetry:
a double ekphrasis
squares the circle.

CONTENTS

THERE IS A SOLITUDE OF SPACE

THE HEART ASKS PLEASURE FIRST

LOVE THOU ART VEILED

NO RACK CAN TORTURE ME

I'VE SEEN A DYING EYE

I MEASURE EVERY GRIEF I MEET

SAFE DESPAIR IT IS THAT RAVES

THEY SAY THAT TIME ASSUAGES

Metka

Tomaž Šalamun

A fragment of a living heart is not like a flat
Wafer, and not as white.
Through a clear glass I am watching limousines.
About lacquer! *No mas! No mas!*
The most fragile springs live to see
The day, even when blessed with the sea's saltiness.
And fish who use enormous
Waters just to be able to swim:
Snow melts only in the mountains.
The holy spirit springs from there
To gather waiting for you, that
water which will lead him to the sea.

Translated by Richard Jackson

INTRODUCTION

This project began a few years ago when I was given a book containing Metka Krašovec's sketches responding to poems by Dickinson, Vallejo, Alojz Gradnik, Amy Winehouse and San Juan de la Cruz. Or better said, it began when I first fell in love with Metka's work in the late 1980s when she and her husband, Tomaž Šalamun, came to Chattanooga for the first time, and then again a few years later when she had a small show of her work at the University of Tennessee-Chattanooga. In the past few decades she has given me work for 5 of my book covers—for there always seemed to be a painting or sketch that fit perfectly to my own poems.

And then it struck me that an interesting project would be to have American poets who knew Metka or her work respond to her responses. I started to discuss the idea with Chad Prevost, a poet and editor, and we came up with a preliminary list of possible contributors. One of the times I visited Metka in Ljubljana, we sat in her kitchen drinking whiskey (only a few sips under doctor's orders) and she revealed to me that sometimes she did the art before she found the verses! Each piece, on a small board about 6.5 by 5 inches, was arranged in a long narrow file box. She had decided, she said, to do more. The project would be endless, and books like this one would extend the life and the art even further.

And so I decided at that point to include other poets, both young and established, who had some connection to Slovene poetry and art, to Tomaž and Metka. Of course, not everyone we asked was able to respond to their satisfaction, something Metka herself understood as we went over the lists. There is not always the necessary personal artistic connection.

The images themselves suggest a movement in and out of night, or perhaps dusk, a marginal space where visions meet, where poetry and art meet, and now where several poetries converse with each other and the art. In some ways her project harks back to medieval illuminated manuscripts, where we seem to travel endlessly in that space between text and art. And so it is, this book is perhaps the first step in that journey for many readers who will themselves continue with their own responses.

—Richard Jackson
Chattanooga, Tennessee

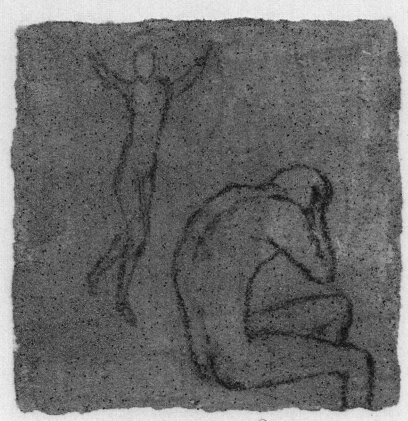

The Heart has many Doors—
I can but knock—
For any sweet "Come in"
Impelled to hark—
Not saddened by repulse,
Repast to me,
That somewhere there exists,
Supremacy—

The Heart
Has Many Doors

Upon the surfaces of water, among their many hillsides
— in fog. They don't quite fit. The same —

– Ralph Angel

Impelled to Hark

Mark Halliday

We have been there
in the place where everything in us said Welcome
to the other Welcome in that place
where just a thin bar of moonlight or streetlight
glanced into the high room where we were
together in shadows in soft urgencies of thrilled
Welcome—it was real it was a real place
high above the ignorant skeptical street
in a sureness we had brilliantly imagined

and to have been there high up secret in that citadel
is to know ever after it is possible
despite whatever hours and years of awkward
quick goodbyes and buses departing
and flat cool emails and doormen saying "No longer here."

Boutonniere

Mary Ruefle

I picked a Cheerio up
off the floor.
I read Rudyard Kipling
then listened to the Beach Boys.
I glanced at a drawing
by someone I know only slightly
then wrote a postcard
saying love you.
She won't even know
who it's from, but the lord of lies & panic
has fled, fluttering people
sit quietly upon their horses,
and anon one enters with a broom
making ready the place.

Dancing Lesson

Barbara Siegel Carlson

St. Theresa saw the soul
as a seven-roomed mansion of diamond
with God in the innermost chamber.
Inside its still dance the spirit can flower.
Like the fireflies blinking on and off
above the grass those long summer nights
I ran across my childhood lawn
chasing after them
to make a cup of light in my hands.

Olivia Townsend

It's true we are just a set of second selves
Dancing around an empty, silent room.

Everyone was outside playing in the petunias
& Emily without the heart to endlessly knock.

There's not much to a heart that only looks good
from far away. A heart must rise like a sphinx with wings.

Or maybe the doors had rooms. Here is a chair
no one can see, an oarage of broken arms for wings.

No Direction

Richard Jackson

You can see in the overturned stump of the giant oak
how many directions the roots explore. The tiny finch
on the fallen branch wants to fly everywhere at once.
I have been watching the cat try to guess what entrance
the mole will make. There are no maps or blueprints
for the heart. It is like trying to figure why the river cut
its ravine here rather than there. Our own choices hover
behind us. Too easily we board up our dreams. Kafka
waited for a lifetime before a door he could have opened.
How many loves have burrowed into the recesses of the mind?
The key is what you write when you write with the heart.

Folded In on Itself

Leslie Ullman

Two antennae finger the sunlit air
hesitating, nearly blind, through moisture
and shades of light, towards the promise
of something green. Such risk
to the soft body made mostly of water
but for the durable house it carries
everywhere—it can wind itself back, any time,
and there reside in a perfect architecture,
labyrinth of chambers curving inward, its legacy
left in millennia of sand, water, and stone.
Ammonite. Nautilus. Common snail. Maker
of proportioned chambers measured by instinct
and uplifting. The Parthenon. Cathedrals
plotting the progress of faith through Europe—
did mankind know exactly why this pleased
the eye? Sunflower, ram's horn and fiddlehead fern,
God's eye replaying the world in its image: spiral.

Meridian

Mark Cox

Night out of day
Day into night
That first marriage
 One horizon
Back to back
One fused spine
 Yet their faces
Dusk and dawn
Turned toward
Each other's
Vanishing
 Glances
Traded sidelong
 What can be
Shared
To rest assured

Love
We are still here
My ocean
Your shore
Neither merely
Extension
Of that other's
Otherness
 How we know
Who we are
Upon waking
To either
Darkness or light
Depending

Nance Van Winckel

Called up. The someone
thinking that
hates the words
entering her.

Entering her, the words
hated that
thinking someone
the Up called.

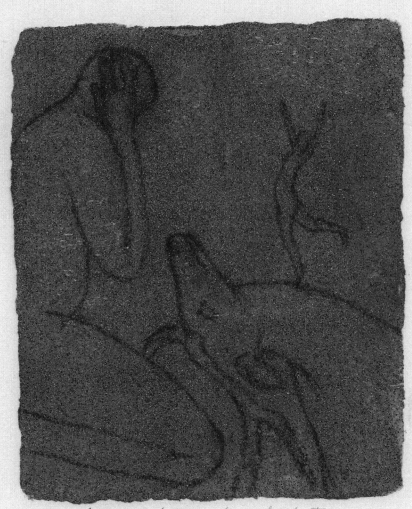

A Wounded Dear - leaps highest -
I've heard the Hunter tell -
'Tis but the Ecstasy of death -
And then the Brake is still!

A Wounded Deer
Leaps Highest

snow water
and three strides
and the eighteen vertebrae I bend to pray

-Ralph Angel

Being Mortal: The Mercy of It I

Dara Wier

let's suppose there had to be one who opened her eyes and looked around
and saw who she loved without end

who can understand that
as when people say poems are hard to understand

what they intend to mean is that life is hard to understand
just as everyone knows the feeling of waiting through the night

for a loved one to appear and eventually be seen to go off alone into
 safe keeping
or for a fever to break or a cough to quiet down

and one no longer stands on the edge of panic
as like they say when nothing dies but something mourns

and how the old masters were right about suffering
when they said anyone knows the feeling of waiting through the night

for a loved one to appear and eventually to be put away for safe keeping
or a fever to break or a cough to quell

and no one any longer stands on the edge of panic
or as they say nothing dies

but something mourns
or how the old masters were right about suffering

or as they say malo mortuum impendere quam
vivum occidere, and in latin no less

Telltale Sign #12

David Rivard

The deer are in the salt meadow again,
back to nip at the grasses after vanishing briefly—
for them, 15 minutes of
wandering among the half-breed
hemlocks & birches—
what's better than damp green living?
The same classical, white, furry rump
of the deer in stories
on these deer. And I didn't worry about them
while they were gone, not exactly,
but—hey, it really wasn't
worry, actually
it was more of an expectation kind of,
like that moment
years ago at mass
when all the churchgoers
good & bad & routinely faithful
turned to shake hands, "the sign of peace,"
reaching toward each other,
their warm palms about to touch,
a feeling of waiting for—what?—
tranquility?—
a calm so naive & innate
that it couldn't help
but descend?
Then the deer returned.
That's all.

Doe

Phillis Levin

To dance
On the throat of a deer
To be slain to be spoken

Alive in a wounded wood
Each branch a line of song
Each bird a burning leaf

To step into dawn
Unsteady unbroken
New as a fawn ready to leap

1000 Whispers

Dean Young

Befriend a ricochet.
Overshadow the funeral.
Hunger is strength.
Hunger is tranquility.
Crush thyme.
Eat her body.
Translucent heart.
Spinal spiral fire.
What strange wolves
we've welcomed to our waltz.

The You That All Along Has Housed You

Leslie Ullman

was once a Druid, an unwed mother, a teller of
white lies, and a friar's apprentice; prefers movement
to meditation, altitude to ocean; has no tolerance
for overhead lighting but is drawn like a crow
to glittery things—also to spiral-shaped things—
can read people like tea leaves but can't find
the scissors or the milk or clean socks even when
they're in plain sight; was once a painter inside
a cave, and a healer slipping quiet as a spider from
a wooden hut at dawn; knows how to work leather
and name the gemstones; knows that a teak bowl
is not the right vessel for holding coins; grew angry at God
lifetimes ago—heartbroken—died broken—and now
gropes its way life after life towards light it still can't define.

The Wound

Richard Jackson

Sometimes the soul ignites from within the body.
It dances with words we long ago closed our ears to.
How many times has the soul become like the dead
space between walls. The shotgun my father carried
seemed to tear open the air, but the imagined sound was
louder. There is an irretrievable sadness in every love.
He never hurt anything except his own heart. We knelt
once beside an abandoned kill. You could see heaven
in his eyes. At dawn the face of a cloud blushed with love

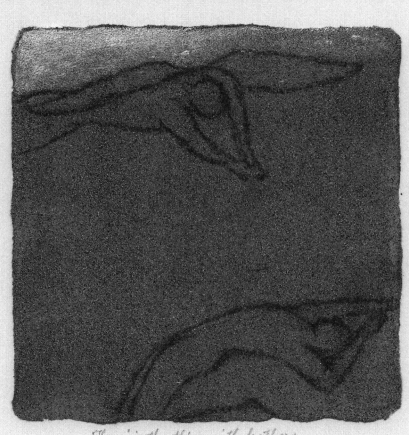

"Hope" is the thing with feathers —

Hope Is The Thing With Feathers

A wonderful
You

– Ralph Angel

Nance Van Winckel

Silly Biddy Soared Too Close
Lost now in the nest of her.

The Living End

William Olsen

And the night crawled back into the cave, and disappeared. Then the cave disappeared. The firelight inside the cave that had forged families, friends, chants, and ochre drawings. Hence, daylight. Acres of ice. Chaos. Microstorm. And at any moment the cold ones may be imagining the warm ones. The ice is doing the crippling without any fierce avenging angels. At the crossing of the street named Life and the street named Death is the School for the Blind. Years I have been watching the sighted learn blindness to get the hang of an invisible world. They slip into character. You can't always tell the blind from the sighted. Both stop at the curb, and the stoplight beeps: faith. But no one is out today. We've all driven home. The cave that birthed the days and nights has disappeared. Brief and small, the feeling of language is a form of surrender. So I do. Warehouses of ice. Not a soul. Blind or sighted so many ways to call the years kind.

Of Last Night's Gathering

Nancy Eimers

Chairs pulled up in a circle
now without their leanings
toward, away—

something so delicate

minus our backs and shoulder blades,
birds or angels
alighting

too low
in the dark.

Matter of Fact

David Rivard

What would it take
and why would I want
to stop gluing these feathers together
and calling it a bird
if it sings
what I'd made as a matter of fact
out of the illusions
of a mind
working working working
on a chain gang?
It sings.

There were my million
worried looks cast at the clock
and at the schlubby waitress who
addressed the other
waitress—the more resourceful,
more amiable waitress—
as "Happy Bunny."

We're all such people,
all of us expanding at the same
speed as the universe—
I mean it, just people—
each of us looking
to spend as much time as possible
with the untidy winds
come from down south to warm us
and credential-check the snow,
because sleep—
a long, deep, Ozarks nap—
beats the hell out of the grave
and all its hopelessness.
It's enough to make you blush.
Jesus. It really is.

For a Time I Believe I Can Touch Them

Leslie Ullman

when silence and the absence
of ambient light conspire to remove
all interference between me
and the stars. It helps if moisture
too, is absent, its molecule-chains
condensed or broken apart,
no longer weighing down the lighter
element, air, or blurring the scrim
of night itself. Once I saw the whole
of a new moon, as though my eyes
could touch the rest of what held aloft
that eyelash of light—as though
my eyes were hands restoring
the whole vast shadowed sphere,
adoring. It was midwinter
in Vermont and minus-seventeen,
the air all clench and crystal, the cold
having subtracted everything. Just me
and the moon, held in an arctic fist, our
dark sides showing themselves each to each,
me tired and a little tipsy, the moon
perhaps wanting to share with something
a part of itself long invisible and untouched.
And I happened to be there. Touched
too, in my own invisible places, which
are many, and were consoled.

Almost Poetry

Hunter Hobbs

Hope is the thing that can't be held, and all the locked doors that we love for their dead bolts and key holes that only know the word almost—the only word that whistles while it bleeds, the only word that dies knowing it never will. The almost-light of almost stars that will spark out before anyone ever hears them. The cusp of memory, the narrow edge of life. The darting rabbit in the corner of the eye, the only trick worth falling for.

Breath

Richard Jackson

Each dream carves its own cave into the wind.
Each breath you draw is a borrowed sky.
Every flower is a mystery. Clouds are gnostic.
The heron is the key. Trout are false leads.
In Mumbai words floated around us like gnats.
Gnats, too, are a key. The heron floats like
A string bow. Your hands pray the same as the sky.
Any time, now the answer steps out of the cave.

The Moon Returns With A Message For Icarus

Laura Behr

When the moon comes to me nightly
I hold up my body, life-spinning in each breath,

grabbing for the moon, until, the moment disappears,
dreams moving just under the surface.

You want to make me look up to you? asks
the moon, moving across the sky's labyrinth.

Maybe heaven is this need as the days recede
into shadow images giving itself over like a promise.

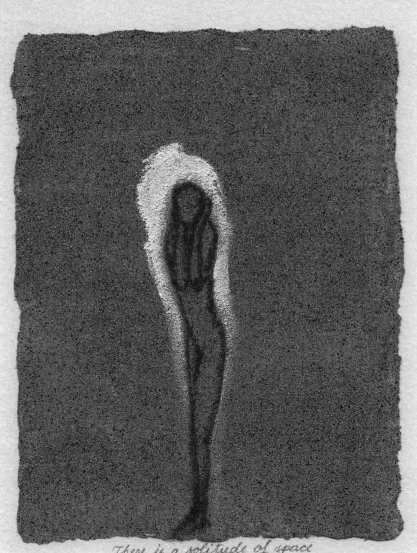

There is a solitude of space
A solitude of sea
A solitude of death, but these
Society shall be
Compared with, that profounder site
That polar privacy
A soul admitted to itself
Finite infinity.

There Is
A Solitude of Space

In perfect shadow my mind shines

– Ralph Angel

Maria's Yellow Coat

David Rivard

I haven't had a whole lot of
what you would call
sartorial awareness until recently.

Also, there are all these road signs
rusted by tears I wanted to cry but didn't—

rusted as if by tears, that's what I mean of course.
Of course.

Under the same confused directives,
where Maria once sat outside the cafe
in her belted, excitable yellow longcoat,
there's an empty chair—
under a weak, early December sun
that floats just above the horizon
like her knitted newsboy cap.

On the sidewalk
near this wrought iron chair
lie a handful of mauled wing feathers,
pretty feathers
not a single passerby
can say no
to picking up; and, rolling them
between thumb & index,
drifting off, some of these people look shocked
to hear the heartbeat in their ears,
as if they held the living bird.

Like a 6-hour visit to a thrift shop,
that's how my day is going—

looking for the cloth booties
worn in hospital operating rooms, the kind
rubber-soled for grip
and quiet
so as not to disturb either patient or doctor
from their meeting with fate,
the surgical team trying hard
not to scare away
the skittish, giddy possibility of healing.

We Defy Augury

William Olsen

Rorschach trees blotting up the stars
black as earth and apparitional as truth
on some little path,
finally memory doesn't stand a chance.

It is dark for another five hours,
then only hints.
Sunlight drapes an unfolded shirt on a familiar chair.
Familiar seeming clouds nose by.

We almost don't think true the night before,
its black trees, black path, black stars,
friends that no longer appear even in dreams.
Our houses shine and huddle like teeth.

You'd think elegy was in a hurry or something.
There is a way to live outside of our lives.
Night, then no night,
the sun is alive, unspeakably finite.

Drawn apart

Cathy Wagner

Together means
you hang around me in a social fabric
made of cold.

"When I am in a room with
people it is not that
myself returns to myself"

in a cold white veil.
I covered my ears at the gray noise.
I wasn't given eyes.

Until the edges found me
I was background
gray noise.

I would be
still and set apart
for company.

The Sheath

Richard Jackson

With every errant word there is a ripple of gravitational
waves that brush, unheard, against us. We want to
command the wind to follow one path. The rudder of
dusk is broken. We sheath our dreams. Nobody is attached.
Everyone fears their own space. We think our words
believe in us. We think a crutch of light will poke down
through the clouds. Instead, eternity drips down the gutters.
One idea forgets what the other idea wanted to whisper.
Still, each self tries to discover its other shedded selves.
The clock, meanwhile, borrows its time from the heart.

Metka

Earl Sherman Braggs

When the mayfly flies down from above
disguised as beautiful, angry love,
the moon, some nights, smiles

at the way you are trapped in tragedy.
To yourself, you laugh,
the sun maybe, you say

on blisteringly hot summer days, but
nobody hates the moon.

Softly, you remember
the soft sweet harshness of being awaken
one morning by the sea.

You know Van Gogh would know
love comes and love goes, but
who knows the intent of a traveler's moon.

Tides ride in on the crest of waves
and tides ride out on the crest of waves and
the painter, the painter, paints perfect,
a picture of all of this.

No Smiles For Emily
 Light too bright for our infirm delight

William Pitt Root

Light, ruthless, blinding, clear
Carves shadows out of char
—all our hopes, each fear.
Strikes just where we are.

Solitude of Space

Emilia Phillips

Yesterday on the uptown C, the car with no air
 conditioning filled and a red-cheeked baby wailed,
 reed warm and milk spittled, not unlike Janis

Joplin, as its nanny tried to pop a rubber
 nipple into its mouth before retreating
 into the diaper bag to find a ring of plastic keys

in red, yellow, and green as, aloud, she blamed it
 on teething, as if in apology, although we were all over-
 heated, some dizzy, and one woman's face, heavy as a clay

death mask, had begun to slide off her jawline like a sheet of ice
 from a glacier, record sea melt…hottest year on record,
 and I held my water
 bottle in turns to my wrists and my throat, news on my phone,

as the man next to me dabbed at his temple with a green
 bandana embroidered at each corner with a fly of black
 thread, one of which I thought was real for the moment

I first glimpsed it, and when I jumped back, startled, my thighs,
 sweat-cemented to the plastic, seared their release
 though I wasn't long distracted, even by pain, from the smell

of sweat and grease and garbage tang, the deep
 chemical edge of the earth under a city
 that whaaapt-whaaapt-whaaapt through the open

window, warm and damp, in time with the tunnel's
 support beams and lamps, it, hypnotic, making me feel
 indistinct, either too much body to be human

or too much brain, a pressure like a thumb
 between my eyes, and even then I could feel the heat
 radiating off the man next to me so that I felt as if we

were touching, even though we were not—I'd have
 told him off if he'd come that close—and that heat
 in the shape of him beyond him, his shoulder

rendered in white-hot ephemeral
 bone beside mine, made me wonder then
 if this is all I would ever know of what it's like

to live in another body, its heat entering
 into mine, and, when he rose at the station
 stop, air rushing in beside, if it was true—

what the linguists said, that throughout our lives
 we are speaking only one sentence, long
 and unresolved, its object implied.

Prodigal

Christopher Buckley

Turn back—
not one of your questions
was resolved beneath the sky
or moved off even a little
with the clouds. . . .
Any bird can read
the map of the air
to home.
 Weariness collects
with the dust in your cuffs,
dust that settles
each evening in the west . . .
what can it matter now
where you stopped
for soup, for bread,
how many seconds
a small cup of light
shimmered in your hand?
Street sweeper,
sidewalk inspector,
bookkeeper of fallen leaves—
what choices are left?
The road ends in the sea,
the spindrift's salt
drying on your cheek. . . .

Someone still needs
to make sense
of philosophy, to herd sheep,
and take in a stray cat.
Throw your arms up
in the face of the past,
its fine powder on the path

leading down to the edge
of town where no one expects you
on that bench outside the bar,
where someone will eventually
stubs a cigarillo and look up
through the smoke, recognizing
the sack of hopelessness
slung over your shoulder,
the one you set off with
half full, half a life ago,
thinking there might be more
in the grab bag of the blue. . . .

Sit a while; sooner or later
they'll hand you a glass
of rough red wine
by the seawall there,
the mist hanging offshore
like the promise of a life to come,
a life just drifting off. . . .

Breathe in the hush,
the old uncertainty
grey as the pearl
of the sinking sun . . .
think of each misery
you sidestepped, realize
how lucky you are to be
here with nothing left
but the empty light of stars
settling over the sea.

Timeline

Trenna Sharpe

Don't you know by now that the stars
are never close enough? I'm sitting at the corner
store, trying to force more than seven folds
into one sheet of paper. Tonight I will not sleep
the way I'm supposed to which shortens my life span
and leaves me no time left to think.
I dig for some more time in the bottom of my pocket
and toss it into the paper cup clutched
in the homeless man's hands
around the crumbling corner of the street.
I try to ignore the rats running
through the sewers down below. I walk in the street
gutters, and slip on wet leaves. I sit in the vacant spot left
when the homeless man gives up and goes.
The concrete cools as soon as he leaves it.
Night staggers drunkenly through the streets
with no one to follow it home. I sit at this
homeless spot like a masthead for the earth
hurtling back towards its beginning. Tomorrow, the next day,
never and then never again. The paper won't fold.
My fingers won't bend in the cold and I don't remember
how I got back to this part. The dogs go to sleep
on the cool side of the store-front. I stay awake
counting on the suicide of dreams. Nobody ever knows
what they're saying. The last crumbs of moonlight
get brushed under the table. The windows board themselves up
for warmth. The stars stand silently above me:
a map back home that I do not know how to read.
I chart a course for the lonely horizon
and slip into the dark spaces between.

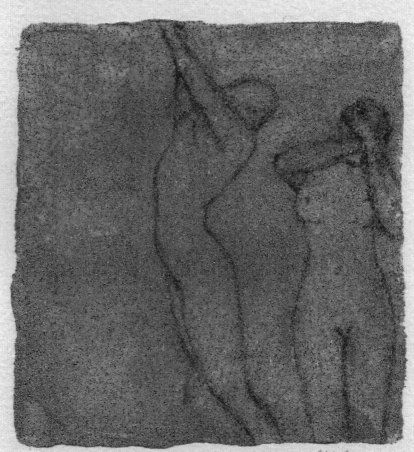

*The Heart asks Pleasure – first –
And then – Excuse from Pain –*

The Heart
Asks Pleasure First

of the mirror my eyes see themselves and stay open

– Ralph Angel

A Little Help

Mark Jarman

Dear headache, do you want to go to sleep?
Sweet backache, do you want to take the stairs?
Oh heartache, here let me get your bags.
Ah bellyache, tell me what's on your mind.

Dear backache, here let me get your bags.
Sweet heartache, tell me what's on your mind.
Oh bellyache, do you want to go to sleep?
Ah headache, do you want to take the stairs?

Dear heartache, do you want to go to sleep?
Sweet bellyache, do you want to take the stairs?
Oh headache, here let me get your bags
Ah backache, tell me what's on your mind.

Dear bellyache, here let me get your bags.
Sweet headache, tell me what's on your mind.
Oh backache, do you want to take the stairs?
Ah heartache, why won't you go to sleep?

Levitation

Pamela Uschuk

Each night the owl of sorrow undresses her
as she pretends to fly from his hands
that may or may not be reaching for her.
How many of us have mistaken Venus
for Jupiter with all its nattering moons
strung like uncut opals along its Equator?
How many of us have believed the lie?
There are men whose tongues cut syllables into stilettos
from the unfurling human cloth of kindness, men
who would build the wall higher
and thicker between countries, who would plant
surveillance cameras in their wives' camisoles.
She can find no nightgown of mercy in her dim closet,
no constellation of hope growing like quartz crystals
her daughter planted in a cool glass of water in her kitchen.
She wants to lick the sweet razors of her own fingers, pull
them like plows down her lover's cheeks,
but they've run off with the owl to count stars
in the bottom of someone else's cup
she may decide tomorrow to borrow or not.

Occlusions

Richard Jackson

A December moon that erases Venus nightly.
Cosmic dust gathering in the heart's corners.
The whole sky turning away. The lake refusing
to reflect it. A world of fractals and blind birds
shattering the windows. The simple pleasure
meteors display penciling towards the horizon.
You have to turn around to see them all.
Otherwise all futures are recurrent tragedies,
all plans will only splatter the paper with
fragments of desperation. Each word a telescope,
each breath a hyphen, each love a question.
You have to let your sentences end with commas.

Gentle Things That Get Out of the Way:

Leslie Ullman

A whisper close to a single ear in the crowd;
hand's touch that barely parts the air
and might be mistaken for breeze; a smile
behind a veil; a smile that lights briefly in one
set of eyes like a firefly set free in the dark;
garden scents that stir memory and withdraw
(or were they imagined?), leaving one
bemused in the skin of a former self; patch of
sun brushing fur; patch of sun moving on
while the window holds the world in place;
the tide leaving gifts in the sand for egrets to find;
fog bringing the lights on, then rolling back to sea.

The Heart Asks Pleasures—First—

Alex Martin

The saddest line is the one
that makes the contour
of your body. Once mine,
against it now I see
another

Two Bodies

Susan Thomas

Reaching outward to
air, water, earth. I come
home in the murmur of stars
the pleasures of bed – rest, sleep, love.
My other body cringes, hiding
her eyes to the world. She penetrates
the heart where her suffering is kept.
Does she wish an end to pain, hiding
her shame of useless days, endless
nights? She asks only
to still her raucous breath.

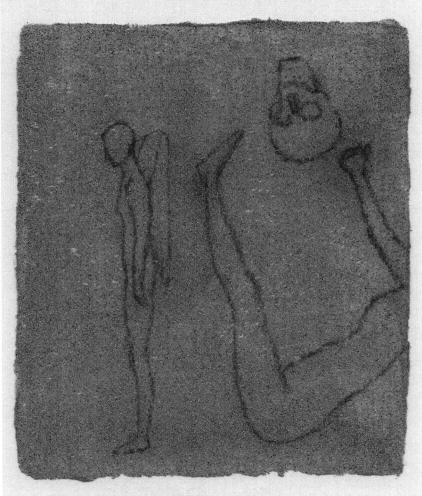

Love – thou art Veiled –
A few – behold thee –
Smile – and alter – and prattle – and die –
Bliss – were an Oddity – without thee –
Nicknamed by God –
Eternity

Love
Thou Art Veiled

Mine

-Ralph Angel

Milkweed

Dean Young

Bright things rise in ripples
like asterisks on fire.
It's ok to toss a skull around.
We are all toys of something.
I myself am a top.
Almost autumn,
this green disguise is getting crinkly.
Even at sixty,
we all have to go back to school.
Smell of sharpened pencils-
does anyone know what that is anymore?
Is anyone out there?

The Veil

Richard Jackson

Sometimes all we had were fisherman's handlines to connect us.
Sometimes we'd search for shells of horse shoe crabs we imagined
as skulls tucked into tidal flats. Gulls poked at whatever tumbled
out of the waves. I remember a dingy just offshore guided by a body
they didn't let us see. Sometimes a whole sky can appear in a patch
of ocean. Beyond what we know there is a whole harvest of stars
we hope exist. No one believed the story that the gulls were disguised
angels. Prayers, however, opened like mussel shells. Replicas of
ourselves tumbled through the immense vacuums of space. Words
swung into orbit around us but sent no signals, and still don't land.

Love Thou Art Veiled

Alex Martin

The soul turns away from god in time
to save itself from immortality,
to claim the promise bone by bone
of unimpeded absence, to love
the way nothing resounds,
the way love itself will settle off the page.
If black is the printed hymn
and white is all hidden instruction
then ash is the expected heresy.
The priest smears the forehead with this mark
of the soul's one victory.

You

Danielle Hanson

The rain wouldn't stop;
it came inside
the mind, like the sound
of canned laughter over music,
like hundreds of chickens
gone crazy
after so many generations.

Blur

Ann Manning

You tell me it is raining in Argentina
the night I arrive at the beach.
And all I can think is that water is distance.
That every raindrop is time.

Can you imagine what creatures survive drinking water?
We must be so stretched and shapeless.
But time is nothing like a raindrop or an ocean.

Time is like a spider.
It hides below our beds
and moves in the darkness we give to sleep.

Time weaves masterpieces
that we scrape at angrily,
like the laced marks left in our corners.

My mother told me only to kill the poisonous ones.
I threw the rest outside—and she laughed, shaking her head
when my clothes were soaked from the rain.

There have always been beginnings the way the seasons change.
There is a point where the changing starts,
like a decision made in the abstract

Unable to manifest all at once:
The first moment of summer
blurs into hours and weeks.

Today was clear because I witnessed its beginning.
Dew sat upon dawn and hung from spiders' webs
like hovering raindrops.

Love, Like the Thief

Cody Taylor

Love, you are a thief. You sell my secrets
often. You do not make time to call your grandmother.
You often forget silence even though it is your native tongue.

You duck between pauses in conversation, like the thief in market stalls.
I've seen you sell my secrets to God, then he swaddles you
in ancient blankets. You are veiled in the folds of my muscles.

I feel you falling through my cells. You are a constant vertigo.
You lurk clumsily through me. I cannot talk about you without
ignoring you. I cannot bless you without cursing you. I cannot
caress you without burying you and pretending to kiss your coffin.

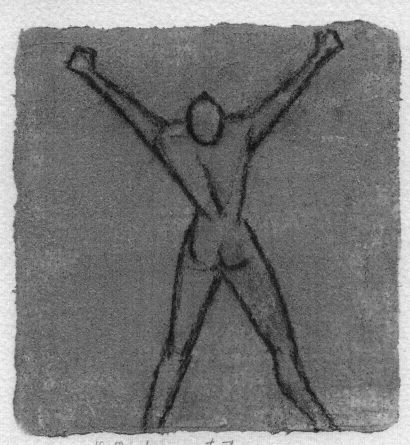

No Rack can torture me —
My Soul — at Liberty —
Behind this mortal Bone
There knits a bolder One —

No Rack
Can Torture Me

for painting
and ritual

on the ground and
on the walls

before the rockslide
by hand

a horse
made yesterday

– Ralph Angel

Being Mortal: The Mercy of It – II

Dara Wier

to smell smoke and think fire
if on this page there was music

the way it is any word's,
some more than others

materiality appears as if it as certain as spots
on a leopard about to take down a baby gazelle

after having done with its mother,
if music were on this page

the way words' shadows are
your death would not wreck me

in the same way
instead it would make some kind of unkind sense

and you would be back where you were
if there were music on this page the way music

hides or bursts forth from every word
as we burst forth out of our mortality

Abyss

Richard Jackson

Does a dead star still claim what light abandoned it?
What is out of sight hijacks the truth. Memories mold
in dungeon light. The heart flies off into another
abyss. A spiteful moon offers no consolation. Deep
in the iris of each eye someone is beheaded, another
dumped into a ditch or exploded in a marketplace
thinking they are a supernova. How seldom the light
keeps its promise. You have to stretch the sky to survive.
Above, fireflies breathe like so many floating lungs.
No scream is loud enough. A blind cosmos sails on.

Not Holding Back

Leslie Ullman

What is required?—a sail
full-belled in the wind. Hand
calm at the wheel. Eye trained on
a vague horizon as the harbor
shrinks behind—safe and known
and too small, suddenly, to contain
the future. The vessel's a sturdy
beetle riding the swells. Which grow.
And the depths swell beneath it,
the invisible realm of sand—restless
waves of it—and coral ridges and
caves, seaweeds, fish drifting
in clouds that hold their own light.
Such a universe—feel the vastness
and pull of it, the terrifying
power under the beetle boat.
Go with it. Let guesswork
guide you through all you can't
see. The sky goes with you.
It will answer when you ask.

Prayer

Chad Prevost

Lord, let me rise from my rumpled sheets
free from the stale air of lost dreams.
Infuse me with a glossolalia of hope.
May it be long till you take me.
May you take me and keep me.
May your face shine upon me.
May you send me back believing in
the power of belief to trip the brainwaves.

Retweets

Brittney Carneal

We share our whole lives on social media;
Posting our happiness in hopes to believe it ourselves.
Sharing the world's drama, making mass hysteria go viral.
"Say a prayer!" Liked. Yet, Heaven, a prayer, never received.
We've flooded the internet with all of our attention and worth;
yearning for a validating notification from another searching
for the same. If we only looked up from the polluted filter,
we would see the ease in which birds fly peacefully
through the sky—retweeting promising melodies
from the solitude of their soaring freedom.

Earth-bound

Bryce Milligan

They're ripping out the rusted rails:
the gravel track-bed snakes away
ribbed with troughs of absent ties
that catch the stormy night's remains
to burn as mirrored rungs at dawn
as if Jacob's ladder had come
asunder with some wild desire
and fallen blessed with angel's fire.

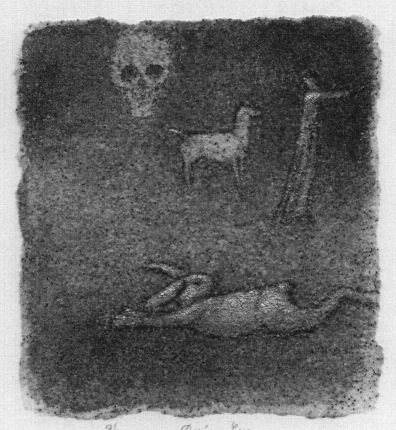

I've seen a Dying Eye
Run round and round a Room —

I've Seen
A Dying Eye

restrained the jewelry that hangs in the garden
a coffee

– Ralph Angel

My Divided Selves

Chad Prevost

Might as well say "divided cells"
the way they split like this. Time, past
pleasures, divine Now, future forever
fissuring. One of my selves split
an atom and captured it
in a bottle. The potential to blow me up—
his own universe—all at once.
Maybe it really is impossible
to live in peace inside ourselves.

The Brooch

Chris Merrill

The jeweler waved her soldering iron like a baton, scattering drops of silver on the wall, the floor, and the old dog, which started from sleep, whimpering, and scampered around the studio, stopping every step or two to lick its tail. Anyone could see she had selected the wrong gems for the brooch commissioned to appease a woman who had not imagined her husband capable of infidelity. Yet she was determined to please her client, aligning her memory of a winter afternoon with him during the siege, in a walkup overlooking the river that no longer froze, with his desire to repair a broken marriage. How they had giggled under the covers about the name she had bestowed on the dog abandoned by its owner: Obscure. The deadline for delivery was the anniversary of the end of the war, which marked the midpoint of their affair. On the bill of sale she called the brooch The Dying Eye. When she blew out the candle on her table, the dog began to howl at the silver stream pouring through the window, fusing the future to the past. This was music to her ears.

Primed

Richard Jackson

There are only so many words between you and your death.
Someone beyond the end of your life keeps watch over you.
In the end you are the corporate story someone has written.
Your past haunts the corners with the other spiders. You have
to leave words like bread crumbs to find your way back.
Darkness blows in like a sandstorm. A crow flicks a wing
and floats against the black sun. And so the heart is primed.

Archeologist

Chad Prevost

The body forgets but the dreams go on re-
remembering themselves.
Like a bat caught in the spelunker's light,
like my hands on a cave wall,
I try to see what is not there.
The body forgets but the memories go on
forgetting what they never knew
to forget. Here is where I fall
to my knees, and crawl
through the narrow gaps.
I find you from your voice, your smell,
tracing your face
with my hands, remaking
the world without light.

To Metka

Matthew Zapruder

Stari Trg
is the name
of the old street
where I sat
one afternoon
in pleasant castle
shadow drinking
tea with a few
mostly silent
young poets,
then consulted
a hand drawn map
leading to your
new paintings,
dusk had been
for too long
next to the canal
lingering
and it was past
the moment
to walk to the opening
where whoever
everyone was
Tomaž had said
would be
to celebrate
your brilliant colors,
little green
dragon statues
on the bridge
watched me
from the table
rise and make

a strange
unpracticed wave
to Tone Primoz
and Gregor who
I did not know
I already knew
were my brothers
then place my feet
exactly where
in that moment
I was wrong
to be sure
Vasko Popa
had thinking
sentient deer,
it sounds too strange
not to be true
but truly for several
minutes like
I was a trolley
and she was going
home from work
a mantis rode
my shoulder,
off she climbed
and I made
a left at the statue,
there was time,
I stood a while,
the little square
had a kiosk,
I handed my money
through its window
for a newspaper
I thought I would
somehow understand,
for when I was young
I had studied
the older sister

language to those
almost familiar words,
in those unconnected
days I walked
through the morning
past the sad kids
with colored hair
and the graves
of Amherst, their
old stern
uncomforting words
carved in stone
comforted me,
they said death
happened
a lot yet here
you go
on your way
to the Russian
to eat a little snow
knowledge chipped
from the vast,
grasping the paper
in the park
now too late
for the party
for the paintings,
I felt something
above me fly
with feathers
by, I was
holding a key,
if I made a left
night would grow
and if I walked
up the stairs
all those books
where nothing
happened would

happen to me,
I went straight
ahead toward
the mountains
always looking back,
and now Tomaž
is gone and so
is Jim and so
many others faster
than I can
write their names
which may be why
in your newest
paintings the figures
live under a translucent
substance holding
grey sand
like words hold
what they mean
but also are,
rabbit, skull,
that's a horse
looking at
a figure looking
back to say
I love you life
but I must go

Skull Song

Pamela Uschuk

> *I've seen a Dying Eye*
> *Run round and round a Room—*
>
> —Emily Dickinson

How often the skull charred at the sockets turns
to watch the heart. It's an old story. Old as rabbit
jittered, kicking gravel at coyote's jaws
snapping the sweet spot at the back of its neck.

In the rock grotto above the Mission, a daughter
tosses the dark braid of her mother, charred at one end
to the feet of the Virgin of Guadalupe
whose eyes are on heaven and its endless grief.

Rabbit and coyote have been in love for years, often watch
the icy eye of Venus die at dawn, while all the white-winged doves
in the city line up on electric wires, thrumming up sun
before hawk takes sky's skull almost tenderly in her skree.

There Is No Cure for Desire

Bryce Milligan

Thwarted, it persists
 A young girl strikes matches
 one after another
 by an alley dumpster

Yielding, it persists
 Rain on the bus window
 bends as acceleration
 overcomes gravity

Denied, it persists
 Three agèd, black-robed priests
 sit in hoar tribunal,
 demand all her details

Fulfilled, it persists
 Creeks spill across the cracked
 drought-wracked plain
 as the vortex descends

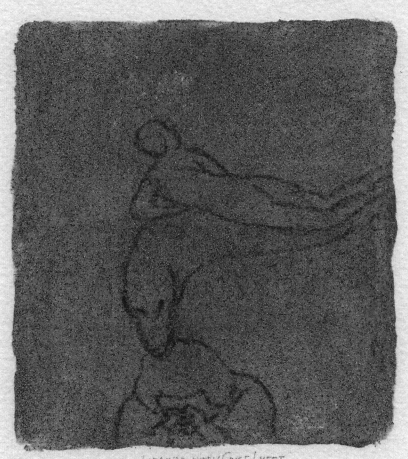

I MEASURE EVERY GRIEF I MEET
WITH NARROW, PROBING, EYES—
I WONDER IF IT WEIGHS LIKE MINE—
OR HAS AN EASIER SIZE.

I Measure
Every Grief I Meet

of thoughts, perhaps—
humorless

and sad—

if not to dream

—Ralph Angel

To Measure with Narrow Probing Eyes

David Wojahn

Heartbeat, heartbeat, the measure of grief a house

*

One hundred forty syllables square, house built

*

On sand & flood plain, house the realm of ghosts

*

& little else. How they yearn for touch & taste.

*

House imbalanced, house where the dead haunt

*

Their breakfast nooks & favorite chairs, the bad dream

*

Of its floor-planks & sagging beams, where iamb

*

Is a trochee, heartbeat a spondee & measure is a taunt

*

To them, the table-rap creak & stutter of séance

*

Where if they speak, it cannot be to us.

*

Claudia, Tomaž, Ales, must you also venture to this place

*

Where the afterlife is ghostly craft & grace

*

Your sorrowing ensorcelled carpentry? Without you we are bereft,

*

Dis-languaged, dumbstruck. O set the beams & measure aright.

Emily

Earl Sherman Braggs

There is a restfulness in walking
towards the sea. Solitude
remembers, but the water's edge forgets
in both directions. Life
balances up against death,
both wanting my love,
my heart where now at dawn
the measured measures the measurer.

Bradley Paul

A poem I had read before
but with a typo now.
"Weig": a missing h;
an h that fell;
an h subject to gravity so
an h that is a thing.
Maybe a man finds it.
He gives it to his wife.
It's nice, she thanks him, but
a week later it's handy and
she folds it up and with it folded
steadies the wonky table.
He sees it at dinner. That's it?
As if it were a napkin?
He pretends he isn't disappointed but
she knows. She knows.
This is how things have become.
There's a poem so we know
there had to be a loss,
but the loss is all h now.

Two Riders

David Rivard

Bicycle-wraiths at 5 p.m. February dusk—
riders pedaling hard against the wind—
wintertime's committed core of
frozen road migrants homing back
from a long day of schooling & business
at stanchioned work stations—the day
was a blur of commercial trade juked up
by daydreams of deliquescent orgasms
amid paperwork, with a few
high-fives for all those quickly solved
but endless flashcard drills—
a family shares its life like so,
a little unpunctual in a world being burnt
to the ground by religionists.
Two riders hurrying into winter wind.
All the mother's care can be heard
in the constant stream of
muttering & exclamations directed back
over her shoulder toward the hooded
child lagging further & further behind.
The boy's lips thick
already with the blooming look
of toothpick ironies.
Papa must have been a rolling stone.
Daddy surely was a rolling pretty stone.

One Day

Deborah Brown

Clouds bang against the side of the barn.
I breathe in road dust.

A flock of leaves flutters to earth.
I hear the end of morning in the hover of geese.

A patch of sunlight moves across the green carpet
and lights the room where you stand.

Rub and thrust, parry and scrape—the wound of the day.
I could touch the wing of a butterfly.

Every Grief

Richard Jackson

In winter the squirrel nests appear clamped to bare branches.
You can feel gravity making its claims. Grief gnaws your dreams.
The script of your heart is unreadable. Your hopes are inverted
candles that spread ashes over the canvas of your life. There is
no path you haven't explored, no driftwood you've found which
brings a hope you could measure. Still, a sacred vision seems to
lounge over every despair. The soul hovers as if to question the grief
you've etched into your eyes. The mind's a plumb line to measure this.

The Noticing

Leslie Ullman

holds things in place
the way roofs clamp houses
to their floors and corners, and trees
send invisible branches deep
into earth, steadying
the commotion of wind.

The noticing tosses the jacket
on the back of a chair.
Smooths it over the narrow ridge
of the present. Replays
the chair's first coat of varnish
and the jockeying of legs
and seat through the doorway.

Every bike lying on its side, every
plastic ball or block left on the lawn
was last touched by a child's hand
before the call to come inside—a hand
sticky with juice, or gritty from digging
a hole through the garden towards China.

Bouquet of spoons and spatulas in a jug,
papers stacked and weighted with a smoky
river stone—smooth, fist-sized—beside three pens
and a postcard from Morocco, clamshell
full of sea glass—all these still-lives left
by the hand in its gatherings and settings-down,
each one a moment. Each one a world.

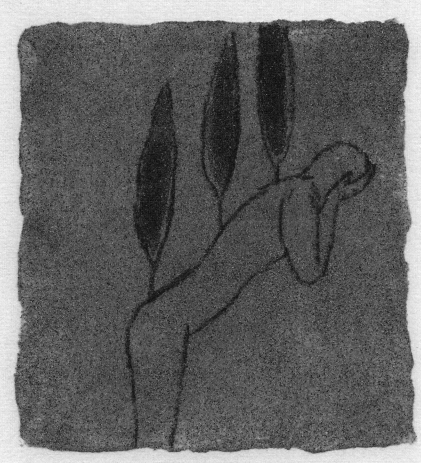

Safe Despair it is that raves —
Agony is frugal.

Safe Despair
It Is That Raves

my own face forbids it
ten-thousand windmills exhausted and visible
smoke rose like smoke from a chimney
"where will the thicket be?"

– Ralph Angel

Frugality

Mark Halliday

I who am apt to get tearful about any instance,
fictional or real, of loyal love that defies time,
or defies prudent self-interest or defies embarrassment
or the pressure of social convention, I am probably
one sort of person whose visible emotion made Dickinson
narrow her fathoming eyes – Dickinson who knew
that what matters is severely apt to be secret and private.
A noisy despair is not despair, she says,
and she implies that my wet eyes are actually
we with relief at not living in the heart of crisis;

And I intend to be educated by Emily – and by life – though
not too fast, not too soon.

Hank Williams Finished by Levon Helm with A Few Lines Thrown In For Emily

William Olsen

The lonely heart holds no hatred or blame

*

I cry and cry the flame

*

Thank God up there

*

They'll pine no more

*

No coffins will be made up there

*

No graves on that bright shore

*

I'm living with days that forever are gone

*

Sometimes I feel like death will never die

*

It always gets stronger when I call your name

*

And it won't let me say goodbye

*

The sky aflame on the cardinal's back

*

Sun gonna shine through the heart of the cardinal

*

Love was supposed to keep out the dark

*

Love I hope to die before I hope to die

Safe Despair

Richard Jackson

There are wounds whose roots entangle our words for them.
There are blades whose tongues eat the ashen air.
There are sails that refuse the wind, untold despairs
that straddle the earth, horrors whose tentacles are endless.
There are warped skies, islands of shadow that are
your only hope. There are hours that have no measure.
There are thorns your fingers become out of prayer.
There is the earth you become trying to grow out of yourself.

Inter-Peritoneal Chemo

Pamela Uschuk

Before each infusion, the recipe seems placid,
carefully weighed, seven and a half pounds
of fluid wrung from platinum, purest of all metals,
in a bag hung from the hook, liquid Book of the Dead
above my head. In the treatment room,
there is no art, just the stern tilt of the hospital bed,
a visitor's steel chair. Even the light is frugal.
I remember the scorpion bite dark as venous blood,
clear as the IV needle a nurse stabs
through the membrane of the port sewn
onto my lower rib to pour toxins into my emptied womb.
It always burns, multiplies thousands of bone splinters
stinging cells, murdering nerves, dulling
my mind, my spine alive, a drawn bow
aimed at heaven, sprouting agony's three stingy feathers.

There's Something Very Unscientific About Zombies

Josh Mensch

Their flesh rocks off, but it doesn't stink.
People on TV never smell them coming.
Where are the wreathes of branches,
sprigs of lichen, insects loosening their joints?
They don't bloat, are rarely overweight.
Is it because they walk? Imagine the dead
were not buried, not burnt,
not left for birds. Imagine the mind
unable to slip its grasp of the body,
but cut off from all sense of it. Imagine tea
dribbling from your loved one's throat
as she smiles at you across the table
one morning, her esophagus blossoming.
Imagine your biceps sloughing off
as you work out at the gym, yet your fanatic
strength remains. Imagine Carl,
the Finance Director, slumping over in his chair
at the board meeting as his hips collapse
and a pile of white infants
pours out of his chest. Carl really should
retire, but he just can't let go.
One day you're at the beach and the woman
next to you vanishes into a breath of dust.
Imagine until that moment you loved her.
Now you're all alone. The swimmers
have stiffened in the current
and the fish nibble on whatever
doesn't dissolve. You've got problems.
First it was a hand, then a foot,
then a more important part of yourself.
You find a branch growing out of your back.
Unlike you, it has a future.
It strains towards the sun as its roots

strangle whatever's left of your heart.
What is left of your heart?
What does the science tell you?
You'd hold your breath, but your lungs
have deflated. If the wind picks up,
your car will go to someone else.

Your Marionette's Eyes

Ata Moharerri

I put a chair inside my head so you could sit down.
See through your marionette's eyes.
How it stands, moves one arm, then the other arm,
how it bends at the knees, kicks up a foot,
how clumsily it walks at first.
It knocks over every prop it touches.
What a private horror, what a remarkable but savable
Idiot, see through your marionette's eyes.
Blow out your pilot light premonitions, your co-pilots,
the floodsmiths, the night leviathans in the terrarium
of your morass mind, forget your skull.
In it you are lost in eternal hallways
of doors without numbers.
What terrorsmith blew out your row of blue candles,
what arrow flew in daylight at speeds which rendered it
 invisible—
it is not invisible just because we cannot see it.
You know this much: it is dusk.
It is raining in a dead language.
It is raining in a deaf tongue, green again,
a mist of green around very far away branches,
children with black candles scribbling upon snowfields,
like trees, a mistranslation.

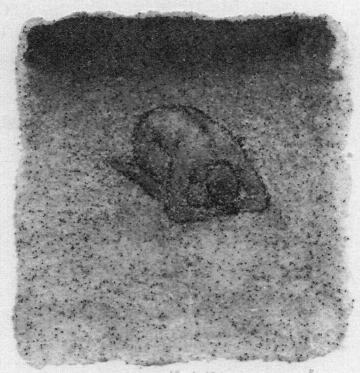

They say that "Time assuages" —
Time never did assuage —
An actual suffering strengthens
As Sinews do, with age —

Time is a Test of Trouble —
But not a Remedy —
If such it prove, it prove too
There was no Malady —

That Say That

Time Assuages

and the fish leapt
and the bees drowned
how many times you kiss my eyes
my parrot-colored spring

– Ralph Angel

Being Mortal: The Mercy of It – III

Dara Wier

If there was music on this page
if music could underwrite this page

if it could hold it up or wipe it out
if it could stand in stead of it

or if music could be all there is
for this time, for this time only

have such as life would they would they burn
in such a way that we would begin

A Rigorous Gift

Leslie Ullman

A gift of gold, of chocolate, of
something cashed in at the right time
is easily received. But some gifts
bring an asking. Not from
the giver, but from within—

an itch, an impulse
towards the paintbrush,
the blank page, the bat, the barre,
the clay, the torch, the breath, the bow,
the blackboard full of equations

and the waiting. Whole days spent
in a shifting, particulate silence.
One can grow old without knowing
one's growing old, suspended like this
between action and uncertainty.

Caveat Sperator

J. Allyn Rosser

When hope approaches —
and she will
when all the rest withdraw —
crouch down, curl into a ball
and roll away.
If she should follow,
pluck her finest feathers
for your pillow;
save the downy others
for a quilt, and dress
her meat for the grill.
Sleep through winter
warmed by what she's good for.
Dream, and dream higher
than ever before, but only
while sleeping,
and sleep before you tire.
If you should wake too soon,
bury her song in the mire,
or play it backwards
for a laugh,
holding your hand
too close to the fire.

Bradley Paul

There's a man in pain but
is it new pain or
an old pain he's been told
must always hurt?
If I speculate some painful disease
it would be the disease of someone I loved,
a disease I've seen —
a disease he's seen,
is that his pain?
But this person he loved,
they died so long ago
he'd forgotten.
What's our problem that
we keep reminding him?

Smithereens

Bill Rasmovicz

A day-by-day weight crushes us, making us mud.
Still, the people appear happy just
to get their bread,

that it rains in strains they've never heard before.
Even if want only endures,

so too do the buildings, mildewed
and wisteria drenched.
If Bernini sculpted bricks they would look like this,
fooled and beautifully forlorn
as doves on a winter branch.

The pink-horizoned mountaintops offer their milk
to the heavens.
Elsewhere, men survive on a lick of salt,
white-teethed, skinny and pretty.

Like the cousin mowing grass bare foot,
losing his toes,
at first you don't feel your fading.

The blocks I've wanted to live on I know I'll never live
just as mosquito wings look more
like suggestions than actuality,
small things, but deadly real things.

It's almost as if knowing doesn't occur until
you've said it,

that commensurate with realization, some forms
of music are better suited to clouds,

some clouds are cellos or violas,
instruments to make the mind wander or blunder,

while war and babies happen when a bow
is pulled across strings.

From Nowhere

Richard Jackson

For that one moment we live where the sky becomes sea
and the sea becomes sky. For that one moment no owl
speaks, no cricket chants. No wave breaks on the rocks.
We begin to forget the reality of things. We walk as if
without shadows, unseen by all we see. Everything is
only itself and reveals nothing. Our words are dusk.
From nowhere comes the clicking of a freight train
on the tracks. It ships one darkness into another.
How many sentences have we used to describe what
we could not describe. Only in a labyrinth of shapes
can we see who we are. Light spills over the horizon
and starts to rise like the tide, lighting the ashen air
as it rises. It files no report, nor any hints of its travels.

Jordan Culotta

the tears of the gods
weigh heavily on the rain-dwellers

About the Artist

Metka Krašovec celebrated her 70th birthday in 2012 with the opening of a retrospective exhibition of her work at the Museum of Modern Art in Ljubljana—the first such retrospective ever given to a female contemporary artist by the museum. This suggests the esteem in which she is held—not only in Slovenian and European art but around the globe. Indeed, her work has been exhibited extensively throughout Europe and the U.S., and two full-color books have been devoted to her work.

Born in 1941 in Ljubljana, Krašovec and her family moved several times throughout her childhood. She lived in Belgrade, San Francisco, and New York before returning to Ljubljana. She graduated in 1964 from the Ljubljana Academy of Fine Arts. She went on to complete post-graduate studies in painting and a Masters of Graphic Art before continuing her education at universities in the U.S. and the United Kingdom. After returning to Ljubljana in 1977, she joined the faculty at her alma mater, becoming one of the youngest professors to teach there.

In 1978, Metka traveled to Mexico, where she fell in love with and later married the Slovenian poet Tomaž Šalamun, one of the most influential and prolific poets of Central Europe over the past few decades. She now splits her time between Ljubljana and her family home at Lake Bled in the Alps. Part of the intriguing story of their meeting appears in the title poem of Šalamun's book, *A Ballad for Metka Krašovec* (Twisted Spoon Press, 2012), which Andrei Codrescu called "sheer condensed delight." As Šalamun describes their romance: "I was constantly thinking about / the letter I'd gotten that morning from Metka/...I collapsed under the table." Over the years, Metka created covers for several of Šalamun's books. She illustrated his *Blackboards* with "Trak," a series of images that traverse a long paper scroll.

As critic Jože Osterman wrote in *Sinfo* (May 2012), sumarizing Metka's career:

> As a one-of-a kind artist, whose paintings are imme-
> diately recognisable, Metka Krašovec created a number of
> entirely new poetics in fine arts, first with the prevailing

reds in her early creative years and, subsequently, with her striking figures predominantly featuring strange heads, a kind of premonition of beings hailing from other galaxies. Finally, her new explosions of colour, which is characteristic of her third creative cycle. The search for beauty as an absolute ideal we can come close to, but cannot quite reach, is, according to the organizers of her retrospective, the essential thread that runs through her fairly heterogeneous poetry of painting.

Metka's work has been exhibited throughout Slovenia and in London, Stockholm, Milan, Graz, Belgrade, Trieste Tunis, Paris, Zagreb, Bonn, Brooklyn, Bucharest, Coventry, San Francisco, Chicago, Alexandria, Brussels, Subotica, Los Angeles, Madrid, Tiblisi, Damascus, Berlin, Dakka, Dubrovnik, New Delhi, Chattanooga, Fredrikstad, Nairobi, Dusseldorf, Rijeka, New York, Bombay, Lisbon, Helsinki, Skopje, Manchester, Budipest, Cambridge, Athens, Venice, Vienna, Sarajevo, Teheran, Marburg, Florence, Bonn, Harkov (Ukraine), Treviso, Zurich, São Paolo, often as publicly commissioned work. Her stained glass windows and frescoes are in the Church of St. Lawrence, Kokrica, Slovenia.

About the Editor

Richard Jackson has published over twenty books, including thirteen books of poems, most recently *Traversings, Retrievals, Out of Place, Resonancia, Half Lives: Petrarchan Poems, Unauthorized Autobiography: New and Selected Poems,* and *Heartwall.* His translations include Alexsander Persolja's *Potvanje Sonca / Journey of the Sun* and Giovanni Pascoli's *Last Voyage* (Red Hen Press, 2010) with Susan Thomas and Deborah Brown. He edited the selected poems of Slovene poets, Iztok Osojnik and Tomaž Šalamun. He also edited nearly twenty chapbooks of poems from Eastern Europe. His own poems and books have been translated into seventeen languages. He was awarded the Order of Freedom Medal for literary and humanitarian work in the Balkans by the President of Slovenia. He is the recipient of Guggenheim, NEA, NEH, and (two) Witter-Bynner fellowships. He also received the AWP George Garret Award for teaching and writing.

Thanks to Madison Bailey, Abigail Rossi and Christina Craig for help in preparing this manuscript.

About the Contributors

Ralph Angel is the author of *Anxious Latitudes, Neither World, Twice Removed, Exceptions and Melancholies: Poems 1986-2006,* and *Your Moon;* his translation of Federico García Lorca's *Poema del cante jondo* was published as *Poem of the Deep Song* (Sarabande Books, 2006).

Earl Sherman Braggs' poetry books include *Syntactical Arrangements of a Twisted Wind, Ugly Love: Notes from the Negro Side of the Moon, Crossing Tecumseh Street, In Which Language Do I Keep Silent, House on Fontanka, Younger Than Neil* and *Walking Back from Woodstock.*

Laura Behr's poems have appeared recently in *Cortland Review, B O D Y* and *Numero Cinq.*

Deborah Brown's poetry book is *Walking the Dog's Shadow*; she is an editor, with Maxine Kumin and Annie Finch, of *Lofty Dogmas: Poets on Poetics* and co-translator with Richard Jackson and Susan Thomas of *The Last Voyage: Selected Poems of Giovanni Pascoli.*

Christopher Buckley's newest book is *Star Journal: Selected Poems.* His 20th book of poetry, *Back Room at the Philosophers' Club,* won the 2015 Lascaux Prize in Poetry from the *Lascaux Review.*

Barbara Siegel Carlson is the author of *Fire Road* and co-translator with Alenka Jelnikar of *Look Back, Look Ahead: Selected Poems of Srecko Kosovel.*

Mark Cox is the author of *Natural Causes, Thirty Years from the Stone* and *Smoulder: Poems,* as well as numerous essays on teaching.

Nancy Eimers's award winning poetry collections include *Grammar to Waking, Destroying Angel, OZ* and *No Moon.* She is an advisory editor for *Third Coast.*

Mark Halliday's collections of poetry are *Thresherphobe, Keep This Forever, Jab, Selfwolf, Tasker Street* and *Little Star.* His prose includes *Stevens and the Interpersonal, The Sighted Singer: Two Works on Poetry for Readers and Writers* and *Against Our Vanishing: Winter Conversations with Allen* (both co-authored with Allen Grossman).

Danielle Hanson's first book is *Ambushing Water.*

Mark Jarman's books of poems are *The Heronry, Unholy Sonnets, To the Green Man, Questions for Ecclesiastes, Bone Fires: New and Selected Poems, Epistles, Far and Away* and *The Black Riviera*. His prose includes *The Secret of Poetry* and, with Robert McDowell, *The Reaper Essays*.

Phillis Levin is the author of four volumes of poetry, *Temples and Fields, The Afterimage, Mercury,* and *May Day,* and editor of *The Penguin Book of the Sonnet*. She was a guest on the BBC Radio 4 program "In Our Time."

Ann Manning, Olivia Townsend, Hunter Hobbs, Jordan Culotta, Cody Taylor and Britteney Carneal are young poets who recently read their work at Vinoteka Movia in Ljubljana, Slovenia.

Alex Martin is a published poet who read her poems in Slovenia and met with Metka Krašovec and Tomaž Šalamun in 2013 in Ljubljana.

Josh Mensch is an editor at *B O D Y* (Prague) whose poems appear widely including *Smartish Pace, Bordercrossing Berlin,* and *Prague's Literary Renaissance 1990-2010*.

Christopher Merrill's books include *Brilliant Fire* and *Watch Fire,* translations of Ales Debeljak's *Anxious Moments* and *The City and The Child,* several edited volumes, and five books of nonfiction including *The Grass of Another Country: A Journey Through the World of Soccer, The Old Bridge: The Third Balkan War and the Age of the Refugee,* and *Only the Nails Remain: Scenes from the Balkan War*.

Bryce Milligan is an award-winning novelist, poet, critic and book designer. His eight collections of poetry include *Alms for Oblivion: A Poem in Seven Parts, Lost and Certain of It* and *Take to the Highway: Arabesques for Travelers*. He is the editor of two major collections of U.S. Latina literature: *Daughters of the Fifth Sun* and *Floricanto Si*.

Ata Moharerri is a contributor to the online Tribute to Tomaž Šalamun. His chapbook is *Wildwood Thrashers*.

William Olsen is the author of *Avenue of Vanishing, Trouble Lights, Vision of a Storm Cloud,* and *Hand of God and a Few Bright Flowers*. He edited with Sharon Bryan, *Planet on the Table: Poets on the Reading Life* as well as *Poetry in Michigan/Michigan in Poetry* with Jack Ridl.

Bradley Paul's books of poetry are *The Obvious* and *The Animals All Are Gathering*, and he has been a script writer for "Better Call Saul."

Chad Prevost's books include *Snapshots of the Perishing World*, *A Walking Cliché Coins a Phrase*, and two edited books, *Breathe: 101 Contemporary Odes* and *Evensong: Contemporary American Poets on Spirituality*.

Emilia Phillips is the author of two poetry collections, *Signaletics* and *Groundspeed* and three chapbooks, most recently *Beneath the Ice Fish Like Souls Look Alike*.

David Rivard is the award-winning author of six books of poetry: *Standoff: Poems*, *Otherwise Elsewhere*, *Sugartown*, *Bewitched Playground*, *Wise Poison* and *Torque*.

J. Allyn Rosser's award-winning poetry books include *Bright Moves*, *Misery Prefigured* , *Foiled Again*, and *Mimi's Trapese*.

Bill Rasmovicz's books of poems include *The World in Place of Itself* and *Gross Ardor* and the forthcoming *Future Erstwhile Century*.

Mary Ruefle's books include *Cold Pluto*, *Memling's Veil*, *Apparition Hill*, *Indeed I was Pleased With The World*, *Post meridian*, *Among the Musk Ox People*, *The Most of It*, *A Little White Shadow*, *Trances of the Blast*, *Selected Poems*, *My Private Property* and a collection of prose, *Madness, Rack, and Honey: Collected Lectures*.

Trenna Sharpe's poems appear in the chap book *Incessant Pipe* (Northern Ireland) and *Industrial Lunch*.

Susan Thomas' most recent collection of short stories is *Among Angelic Orders*. Her books of poetry include *The Empty Notebook Interrogates Itself*, *State of Blessed Gluttony* and a translation, *Last Voyage: Selected Poems of Giovanni Pascoli* (with Deborah Brown and Richard Jackson). Two chapbooks are *The Hand Waves Goodbye* and *Voice of the Empty Notebook*.

Leslie Ullman is the author of *Progress on the Subject of Immensity*, *Slow Work Through Sand*, *Dreams by No One's Daughter* and *Natural Histories*. She teaches at Vermont College of Fine Arts and is emeritus professor at University of Texas-El Paso, where she was Director

of the Creative Writing Program and established the Bilingual MFA Program.

Pamela Uschuk is the author of numerous chapbooks and several volumes of poetry including *Blood Flower, Finding Peaches in the Desert, One-Legged Dancer, Scattered Risks, Crazy Love (American Book Award), Wild in the Plaza of Memory,* and *Without the Comfort of Stars.* Joy Harjo and other musicians joined Uschuk on a CD of *Finding Peaches in the Desert.*

Nance Van Winckel's poetry books include *Pacific Walkers, No Bad Girl, The Dirt, Beside Ourselves* and *After a Spell. Ever Yrs* is a novel in the form of a photographic album. She is the author of four books of short stories, including *Boneland.*

Catherine Wagner's collections of poems include *Nervous Device, My New Job, Macular Hole, Miss America,* several chapbooks and an anthology she co-edited with Rebecca Wolff, *Not for Mothers Only.*

Dara Wier is the author of numerous collections of poetry, including *You Good Thing, Selected Poems* (2009), *Remnants of Hannah, Reverse Rapture, Hat On a Pond, Voyages in English, Our Master Plan, Blue for the Plough, The Book of Knowledge, All You Have in Common, The 8-Step Grapevine,* and *Blood, Hook & Eye.*

David Wojahn's collections of poetry include *Icehouse Lights, Glassworks, Mystery Train, Late Empire, The Falling Hour, Spirit Cabinet, Word Tree* and *Interrogation Palace: New and Selected Poems,* as well as a collection of essays on contemporary poetry, *Strange Good Fortune* and several edited books.

Dean Young's eleven books of poems include, most recently *Shock by Shock, Bender: New and Selected Poems* and *Primitive.* He is also the author of *The Art of Recklessness: Poetry as Assertive Force* and *Contradiction,* book of prose about poetry.

Matthew Zapruder is the author of several collections of poetry, including *Sun Bear, Come On All You Ghosts, The Pajamaist* and *American Linden.* He collaborated with painter Chris Uphues on *For You in Full Bloom,* and co-translated with Radu Ioanid, Romanian poet Eugen Jebeleanu's *Secret Weapon: Selected Late Poems.*

Wings Press was founded in 1975 by Joanie Whitebird and Joseph F. Lomax, both deceased, as "an informal association of artists and cultural mythologists dedicated to the preservation of the literature of the nation of Texas." Publisher, editor and designer since 1995, Bryce Milligan is honored to carry on and expand that mission to include the finest in American writing – meaning all of the Americas, without commercial considerations clouding the choice to publish or not to publish. Technically a "for profit" press, Wings receives only occasional underwriting from individuals and institutions who wish to support our vision. For this we are very grateful.

Wings Press attempts to produce multicultural books, chapbooks, CDs, DVDs and broadsides that, we hope, enlighten the human spirit and enliven the mind. Everyone ever associated with Wings has been or is a writer, and we know well that writing is a transformational art form capable of changing the world, primarily by allowing us to glimpse something of each other's souls. Good writing is innovative, insightful, and interesting. But most of all it is honest.

Likewise, Wings Press is committed to treating the planet itself as a partner. Thus the press uses as much recycled material as possible, from the paper on which the books are printed to the boxes in which they are shipped.

Associate editor Robert Bonazzi is also an old hand in the small press world. Bonazzi was the editor and publisher of Latitudes Press (1966-2000). Bonazzi and Milligan share a commitment to independent publishing and have collaborated on numerous projects over the past 25 years.

As Robert Dana wrote in *Against the Grain,* "Small press publishing is personal publishing. In essence, it's a matter of personal vision, personal taste and courage, and personal friendships." Welcome to our world.

Colophon

This first edition of *The Heart's Many Doors: American Poets Respond to Metka Krašovec's Images Responding to Emily Dickinson* , edited by Richard Jackson, has been printed on 55 pound EB "natural" paper containing a percentage of recycled fiber. Titles have been set in Aquiline Two and Bernard Modern type, the text in Adobe Caslon type. All Wings Press books are designed and produced by Bryce Milligan.

On-line catalogue and ordering available at www.wingspress.com

Wings Press titles are distributed to the trade by the Independent Publishers Group www.ipgbook.com

Also an ebook.